More SHALOM COLORING

COLORING

Bible Mandalas for Contemplation and Calm

with artwork by

Freddie Levin, Judy Dick & Ann D. Koffsky

BEHRMAN HOUSE

www.behrmanhouse.com

To my fellow Purim shpielers at Temple Beth Israel
—FREDDIE SHENEVERGETSTOBEESTHER

To my father, whose love of the Bible and
its rich stories inspires me to turn to it as a source of beauty
—JUDY

For Adira, in honor of her bat mizvah
—ANN

PROJECT EDITOR: Ann D. Koffsky
DESIGNER: Annemarie Redmond
EDITORIAL CONSULTANT: Rabbi Martin Cohen

Copyright © 2016 Behrman House, Inc.
Springfield, NJ 07081
ISBN: 978-0-87441-923-8
Printed in the United States of America

Library of Congress Cataloging-in-Publication Data
Names: Levin, Freddie, author, illustrator. | Dick, Judy, author,
 illustrator. | Koffsky, Ann D., author, illustrator.
Title: More shalom coloring : Bible mandalas for contemplation and calm /
 with artwork by Freddie Levin, Judy Dick, Ann D. Koffsky.
Description: Springfield, NJ : Behrman House, [2016] | ?2016
Identifiers: LCCN 2016002309 | ISBN 9780874419238
Subjects: LCSH: Coloring books. | Bible—Illustrations.
Classification: LCC NC965.9 .L48 2016 | DDC 745.6/7—dc23
LC record available at http://lccn.loc.gov/2016002309

Art credits:
Cover by Ann D. Koffsky with color by Freddie Levin
Freddie Levin: 1, 3, 7, 11-39, 45, 49, 57-65, 71, 72
Judy Dick: back cover, 9, 41, 43, 47, 51, 53, 67, 69
Ann D. Koffsky: 5, 55

WELCOME TO *MORE SHALOM COLORING*!

The Bible itself has no pictures. Made from parchment and ink, it contains only words on a page. Yet, it is full of remarkable imagery that has inspired three great religions and formed narratives that have shaped the world's culture.

A snake curling around a tree. Animals marching in pairs. An infant among the river rushes. Each of those images, and many more, evoke stories, symbols, and meaning.

Inside these pages you will find artists' interpretations of these compelling tales. But their work remains unfinished—they await your own artistic contribution, and we invite you to bring your own creativity to them.

Use the tools that speak to you: Colored pencils, watercolors, gel pens, or brush markers will all work well. Choose colors that evoke meaning and emotion: Dramatic and angry reds might be ideal for a confrontation between Moses and Pharaoh, while warm tones that suggest camaraderie and friendship might be the right hues for a depiction of Ruth with Naomi. The only limit is your own imagination, and whatever you decide, the results will be unique and lovely.

So enjoy yourself; relax into the beauty, pattern, and biblical quotes within; and may they be an inspiration to you for calm and contentment, joy and happiness.

And God saw everything
that God had made,
and behold, it was very good.

—GENESIS 1:31

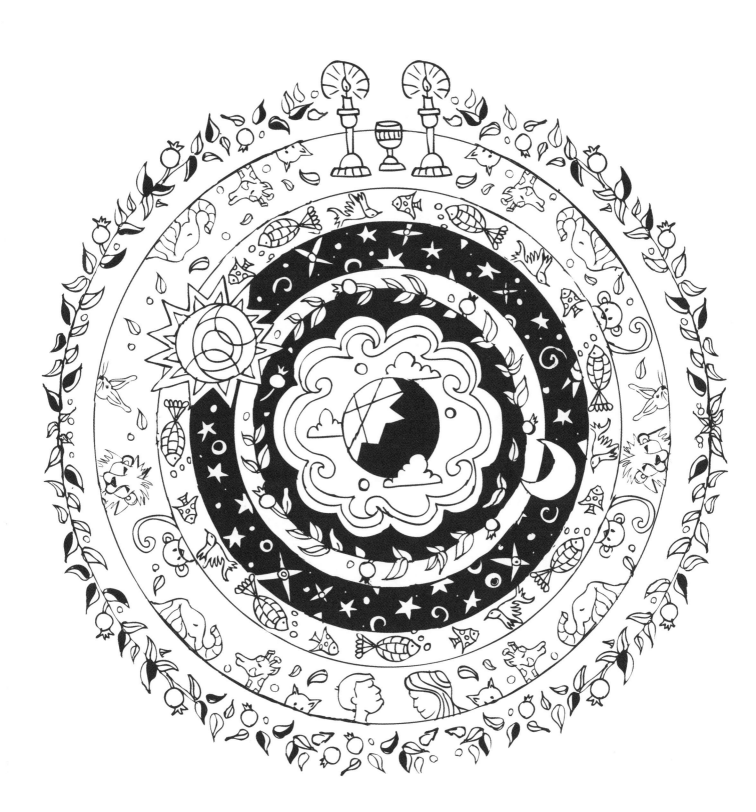

And out of the ground
God made grow...the Tree of Life in
the midst of the garden, and
the Tree of Knowledge of Good and Evil.

—GENESIS 2:9

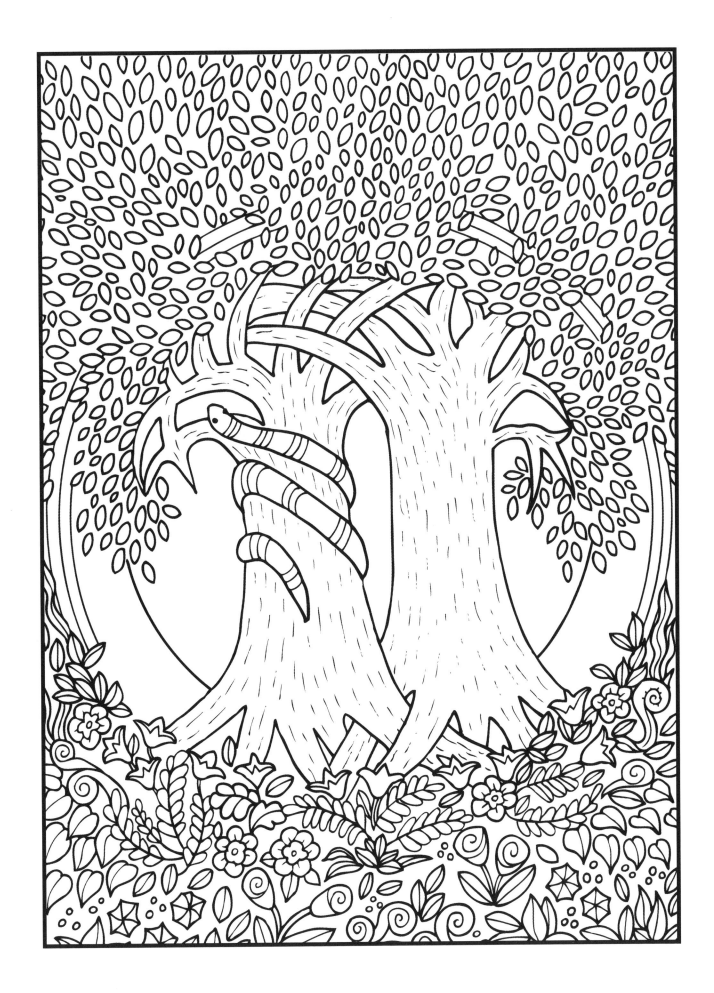

And of every living creature...
two of every sort you
shall bring into the ark to keep
them alive with you....

—Genesis 6:19

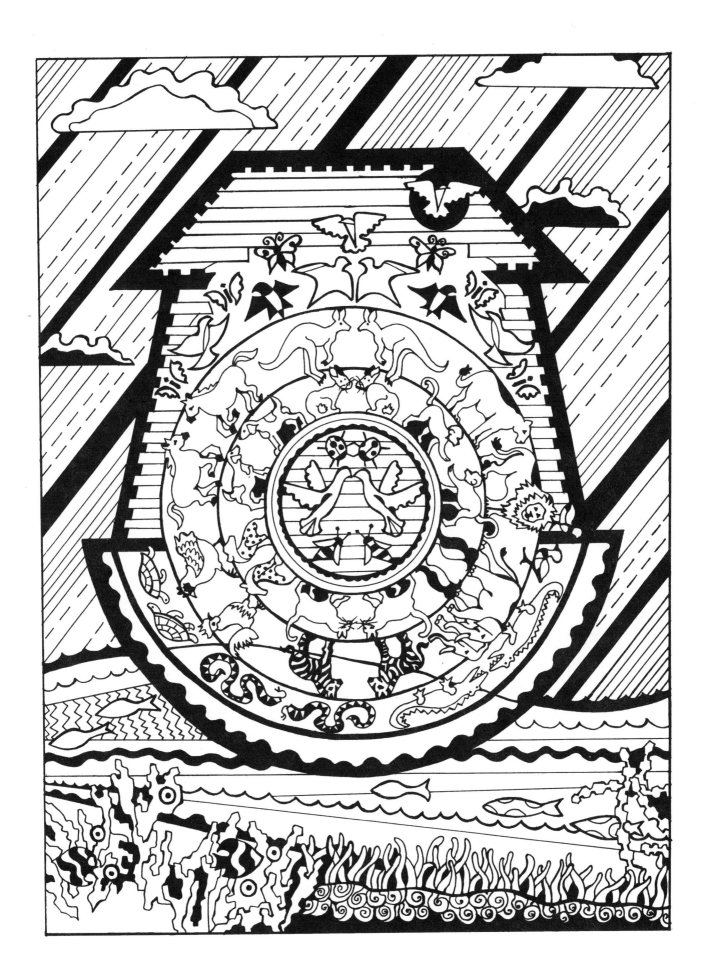

When the rainbow is in the cloud,
I will look upon it and
remember the everlasting Covenant
between God and every
living creature....

—Genesis 9:16

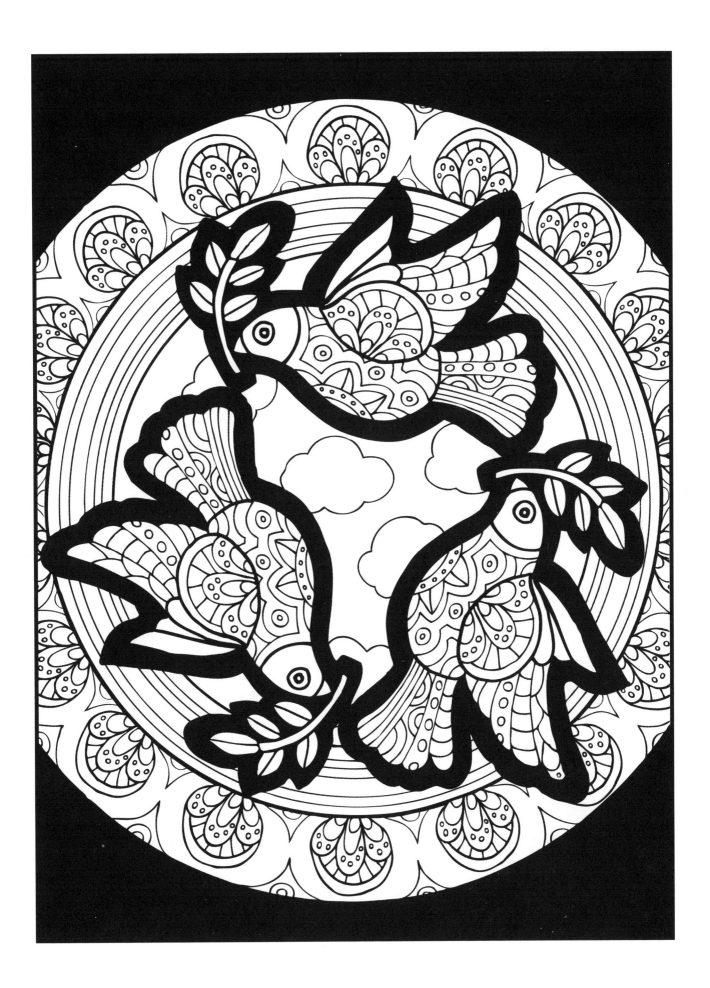

That is why it was called Babel;
because God confused
the language of all the earth....

—Genesis 11:9

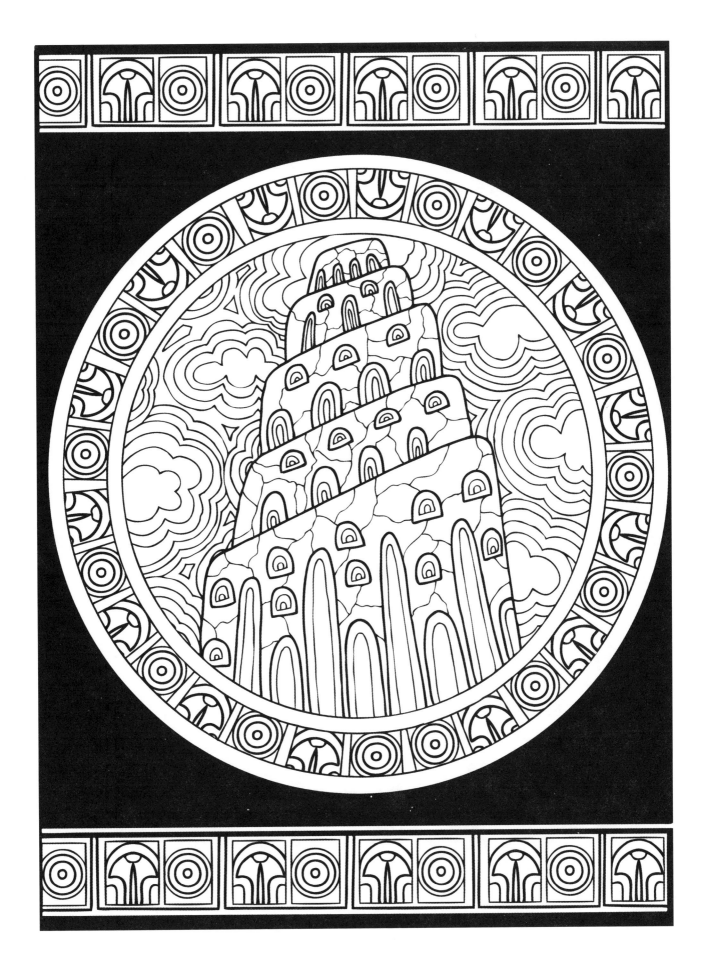

[Abraham] lifted up his eyes
and looked, and lo, three men stood
near him; and when he saw them,
he ran to meet them from the tent door....

—GENESIS 18:2

...[Rebekah] hastened, let down
her pitcher upon her hand, and gave him drink.
And...she said: "I will draw [water] for thy camels
also, until they have done drinking."

—GENESIS 24:18-19

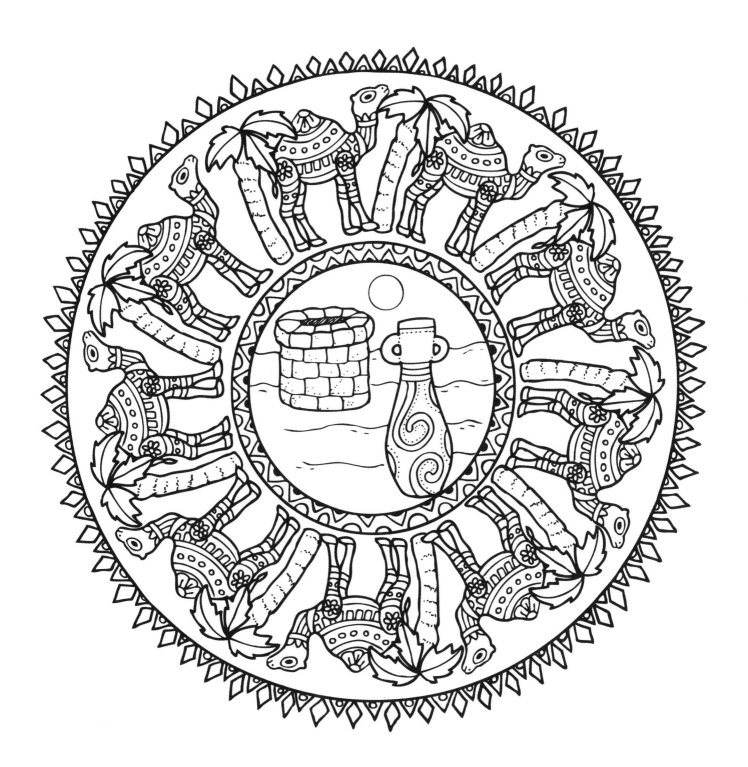

[Jacob] dreamed, and behold,
a ladder was set up on the earth, and
the top of it reached to heaven;
and behold, the angels of God were
ascending and descending on it.

—Genesis 28:12

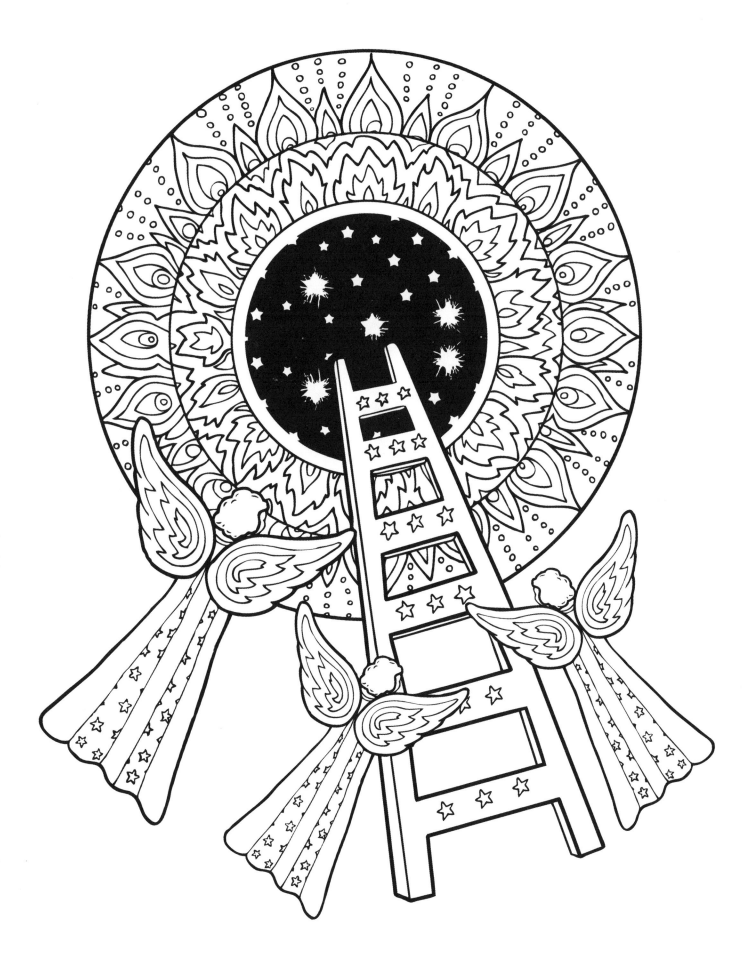

Now Israel loved Joseph
more than all his sons...and made
him a coat of many colors.

—Genesis 37:3

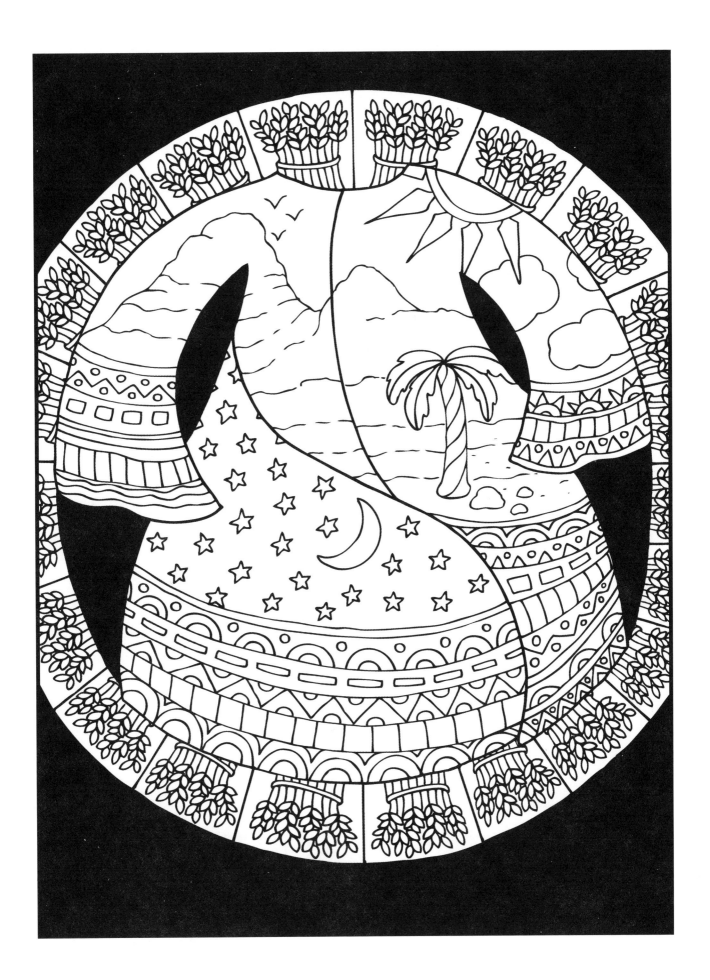

All these are the twelve tribes of Israel,
and this is what their father [Jacob] spoke
unto them and blessed them....

—GENESIS 49:28

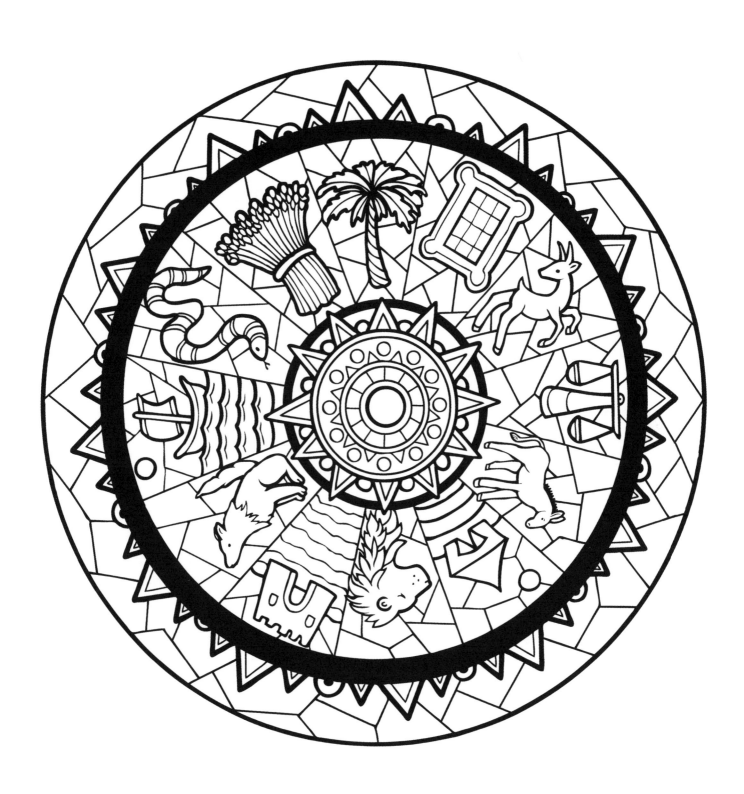

The daughter of Pharaoh...
saw the basket among the reeds....
She opened it and saw the child,
a boy crying. And she had
compassion on him....

—Exodus 2:5-6

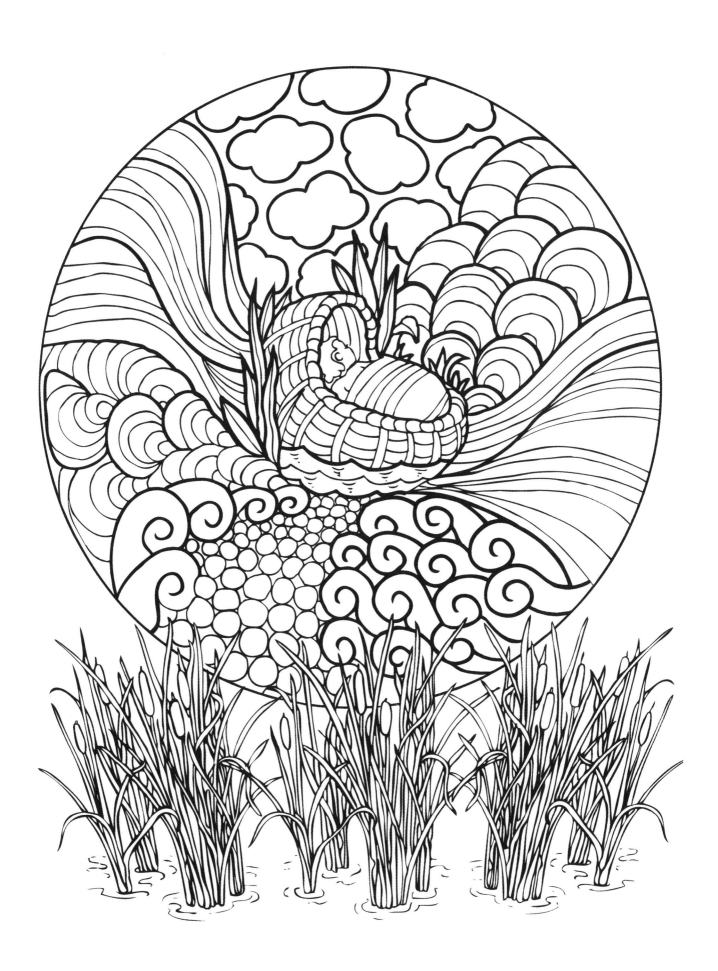

...the angel of God appeared to [Moses]
in a flame of fire from the midst
of a bush; and he looked, and behold,
the bush burned with fire, and the
bush was not consumed.

—Exodus 3:2

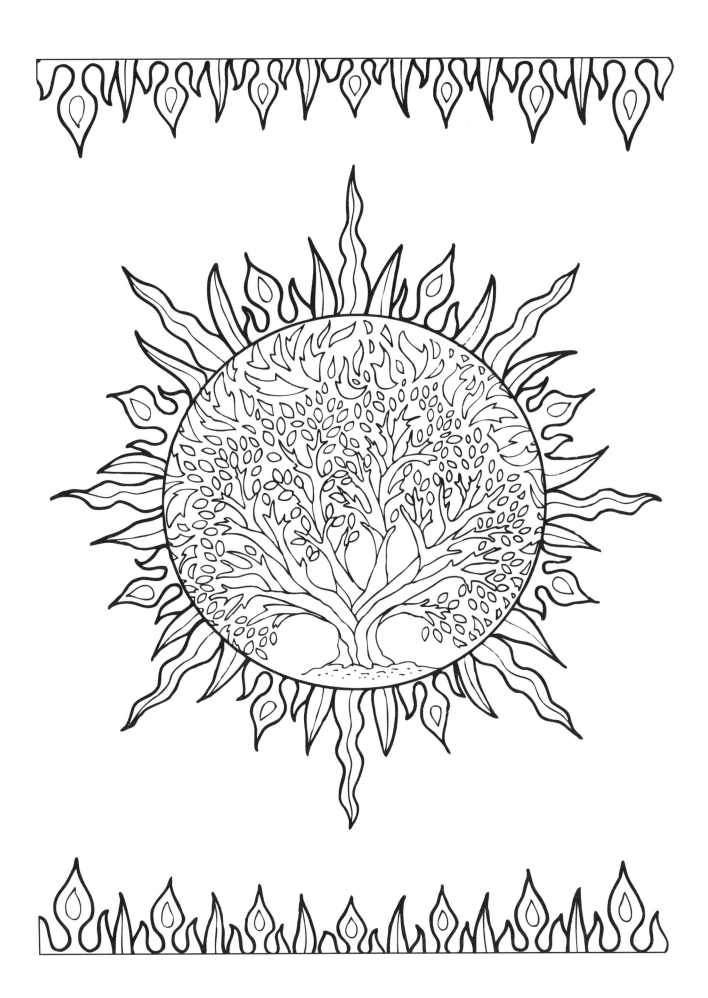

I have come down to deliver
my people out of the hand of the Egyptians,
and to bring them up to...
a land flowing with milk and honey....

—EXODUS 3:8

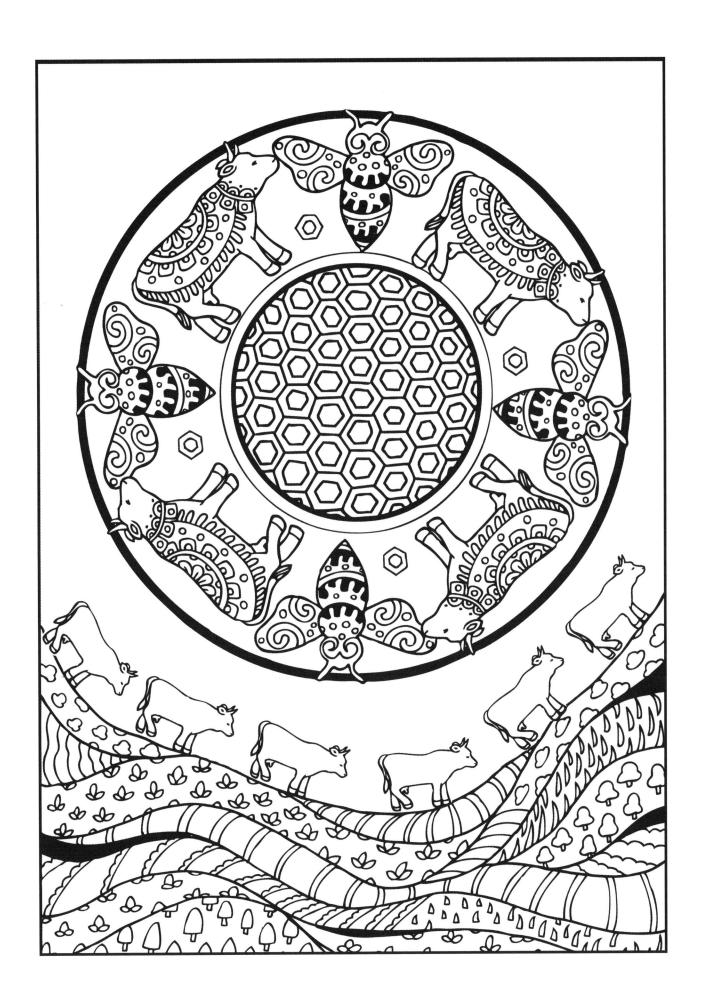

...Moses and Aaron came
and said to Pharaoh: "Thus says the God
of Israel: Let My people go...."

—EXODUS 5:1

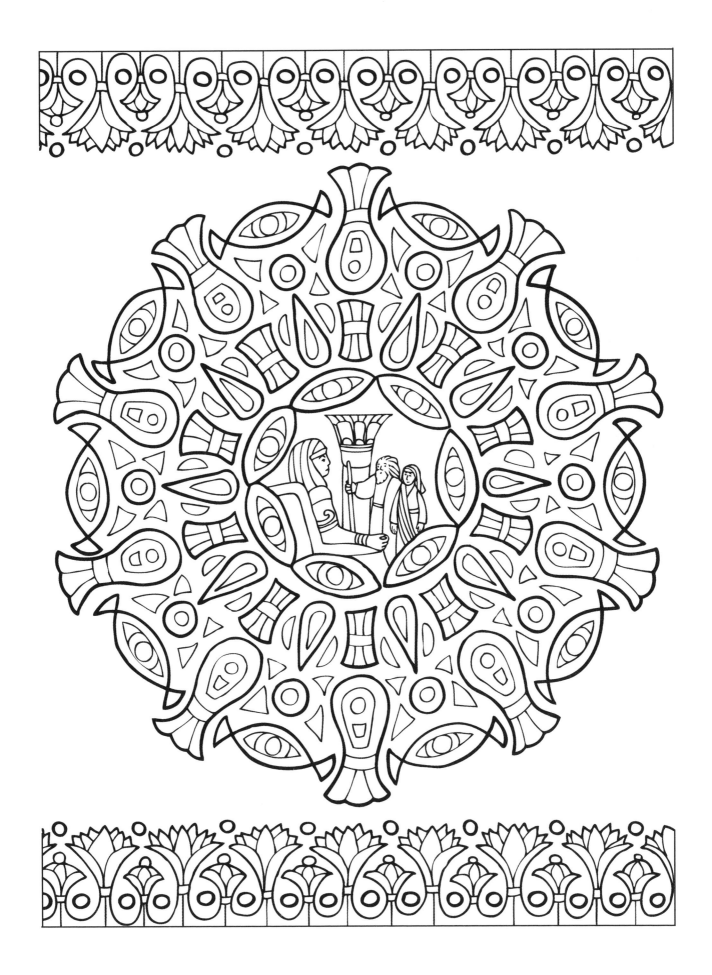

God went before them by day
in a pillar of cloud, to lead them the way;
and by night in a pillar of fire,
to give them light....

—Exodus 13:21

And the children of Israel
went into the midst of the sea
on dry ground....

—Exodus 14:22

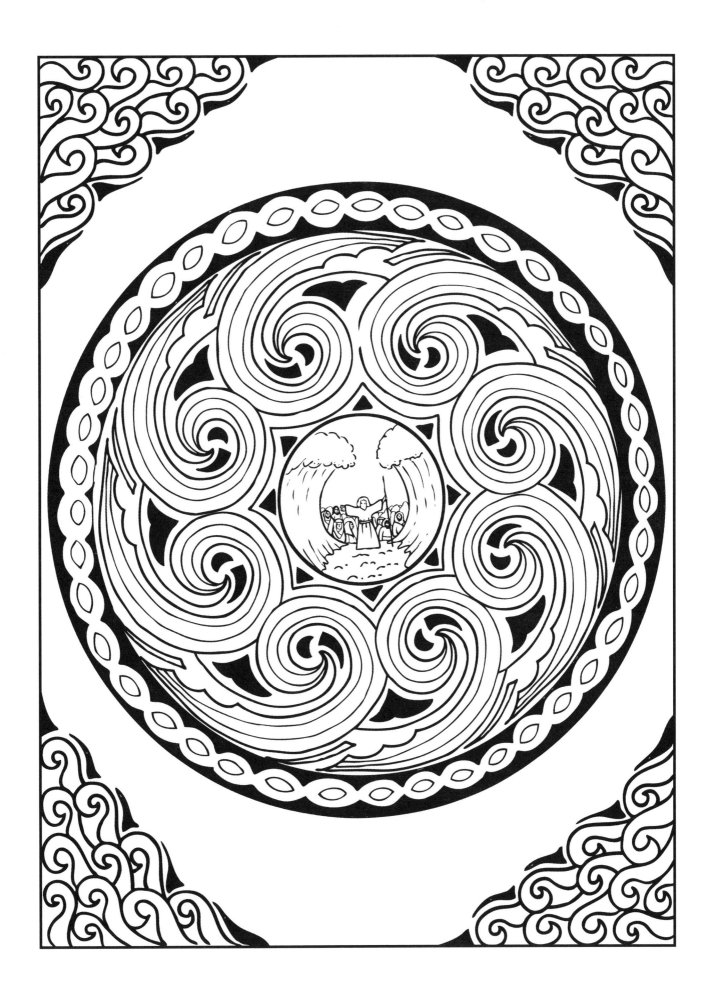

Then Miriam the prophetess,
sister of Aaron, took a timbrel in her hand;
and all the women went out
after her with timbrels and with dances.

—Exodus 15:20

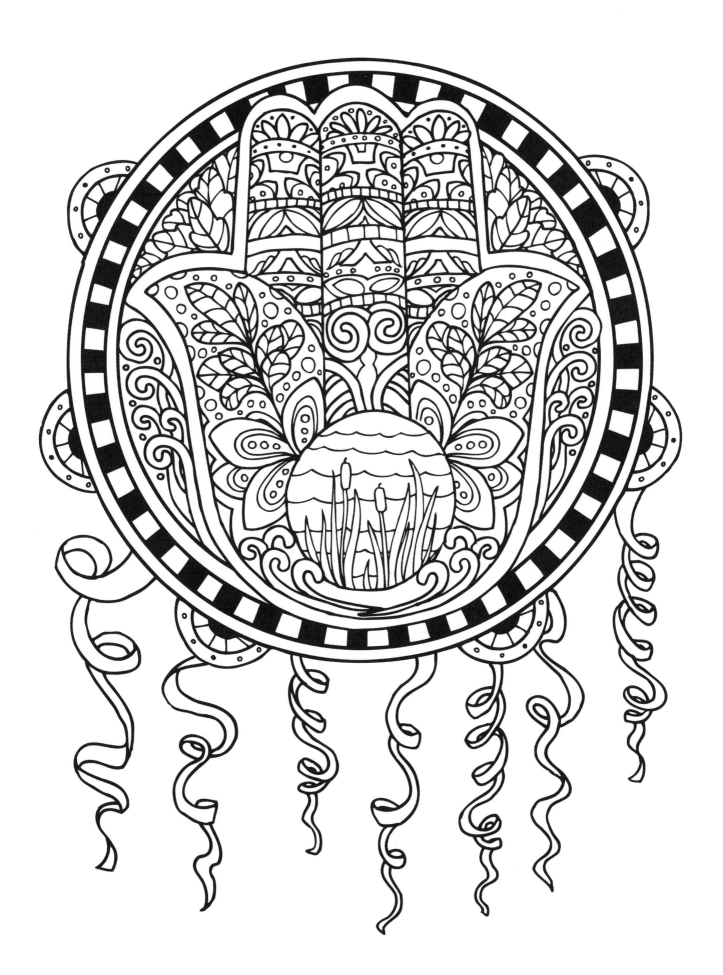

...[T]here was thunder and lightning and a thick cloud upon the mount, and the voice of a shofar exceedingly loud; and all the people that were in the camp trembled.

—Exodus 19:16

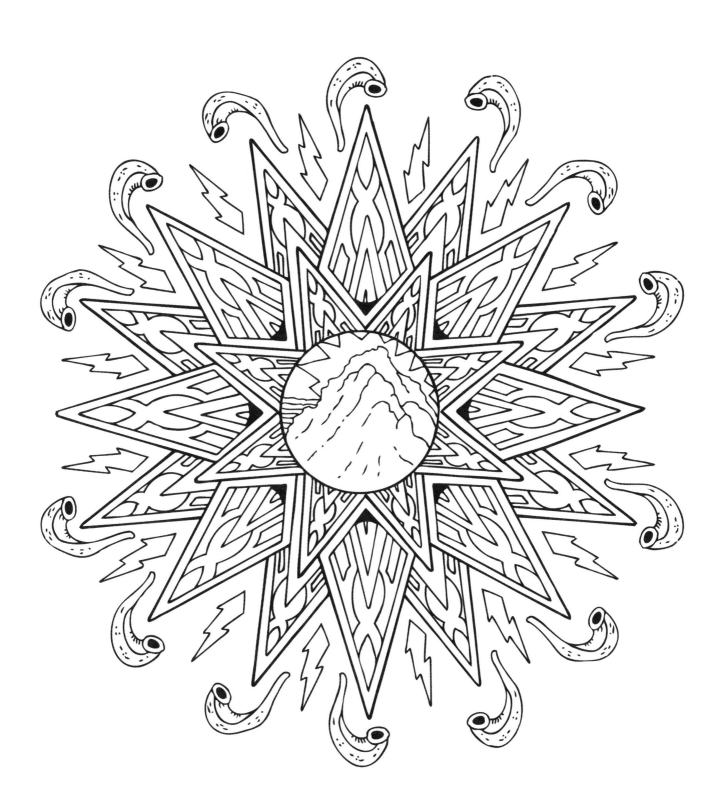

And they came, every one whose
heart stirred them, and every one whose spirit
made willing, and brought an offering
for God, for the work of the Tent of Meeting....

—Exodus 35:21

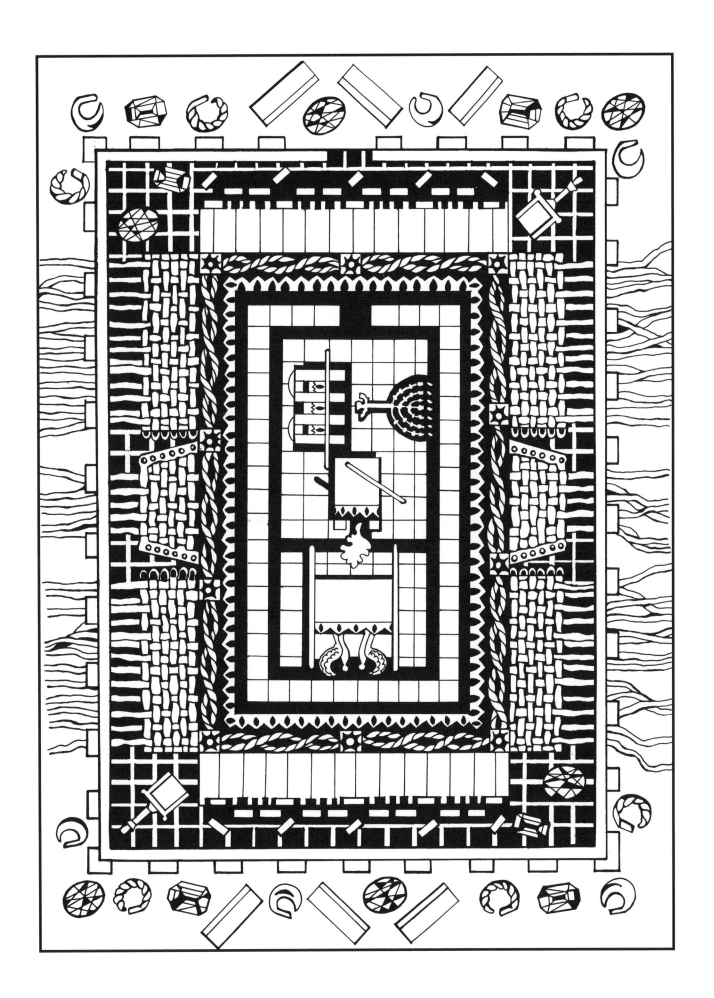

For thy God brings you into a good land...
a land of wheat and barley,
and vines and fig trees and pomegranates,
a land of olive trees and honey....

—Deuteronomy 8:7-8

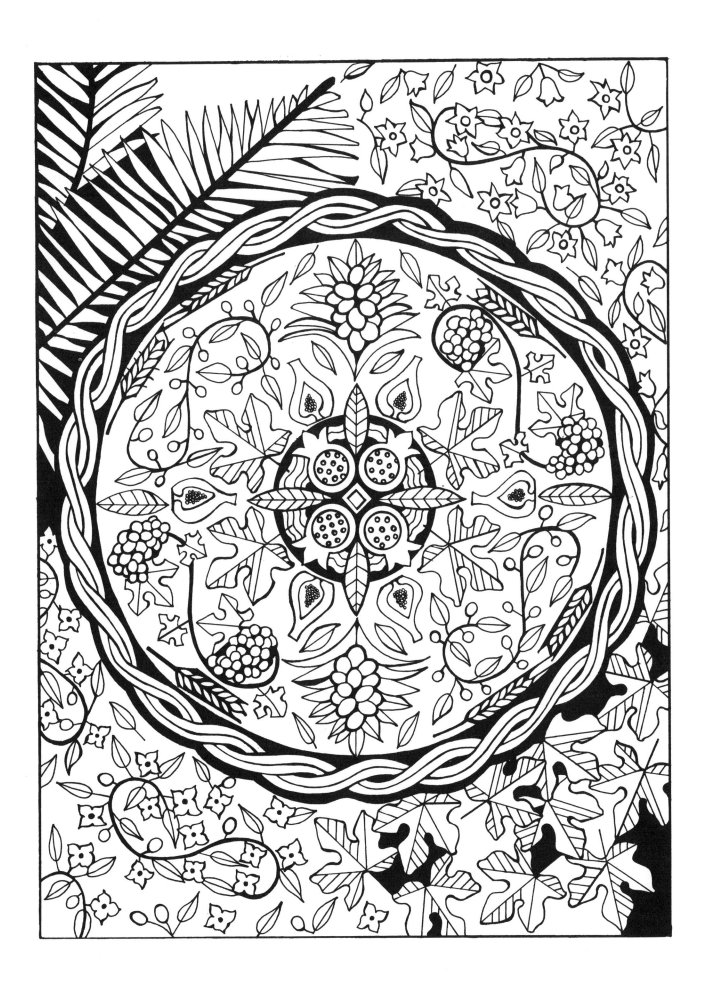

Now Deborah...was a prophetess....
She sat under the palm-tree...and
the children of Israel came up
to her for judgment.

—JUDGES 4:4

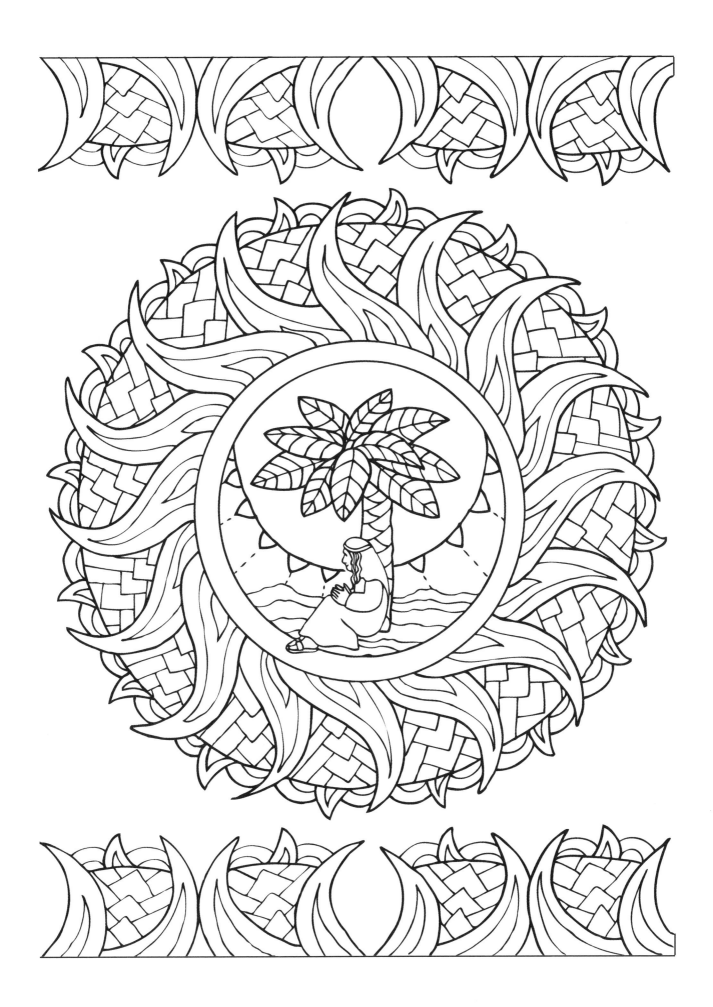

...David would take up his lyre and play....

—1 Samuel 16:23

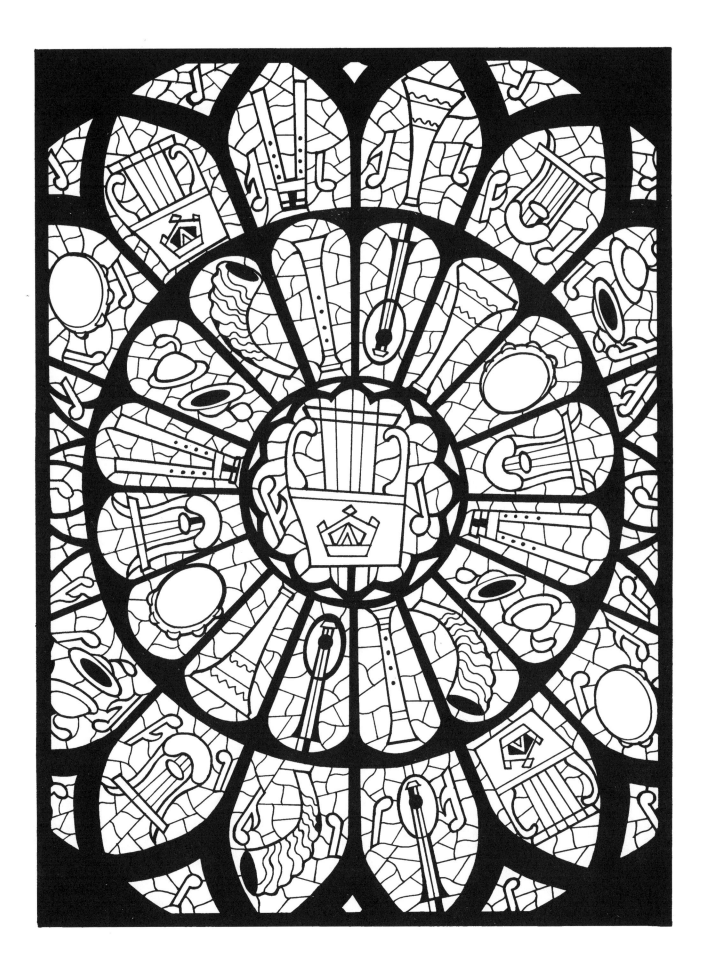

David said to Saul, "Let no one
lose heart; [I] your servant
will go and fight this Philistine."

—1 Samuel 17:31

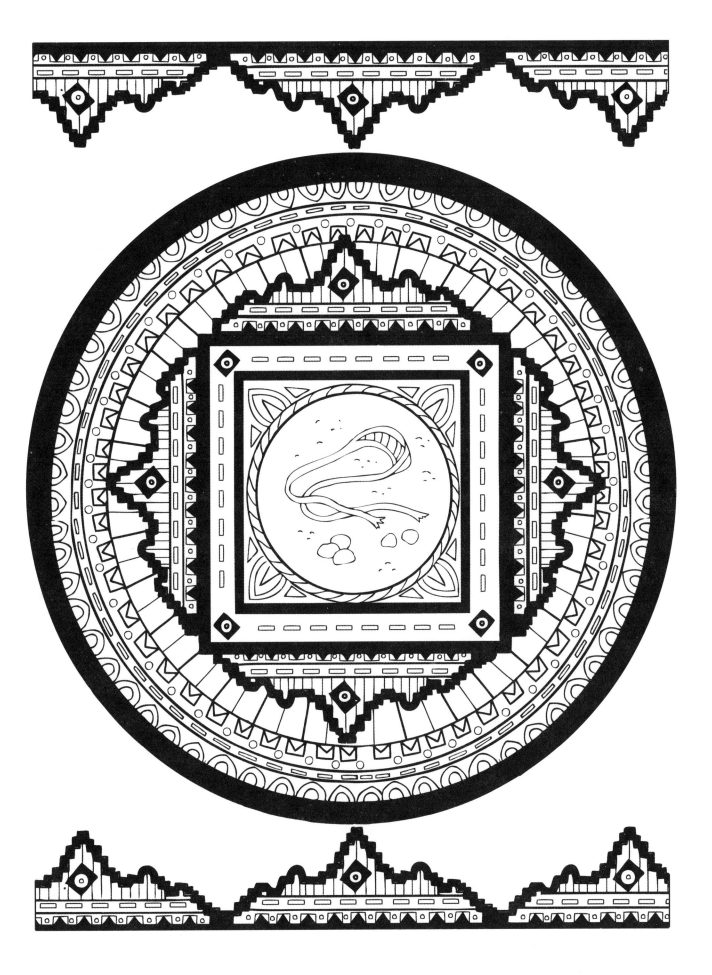

...And [God] will assemble the dispersed
of Israel and gather together the scattered of
Judah from the four corners of the earth.

—Isaiah 11:12

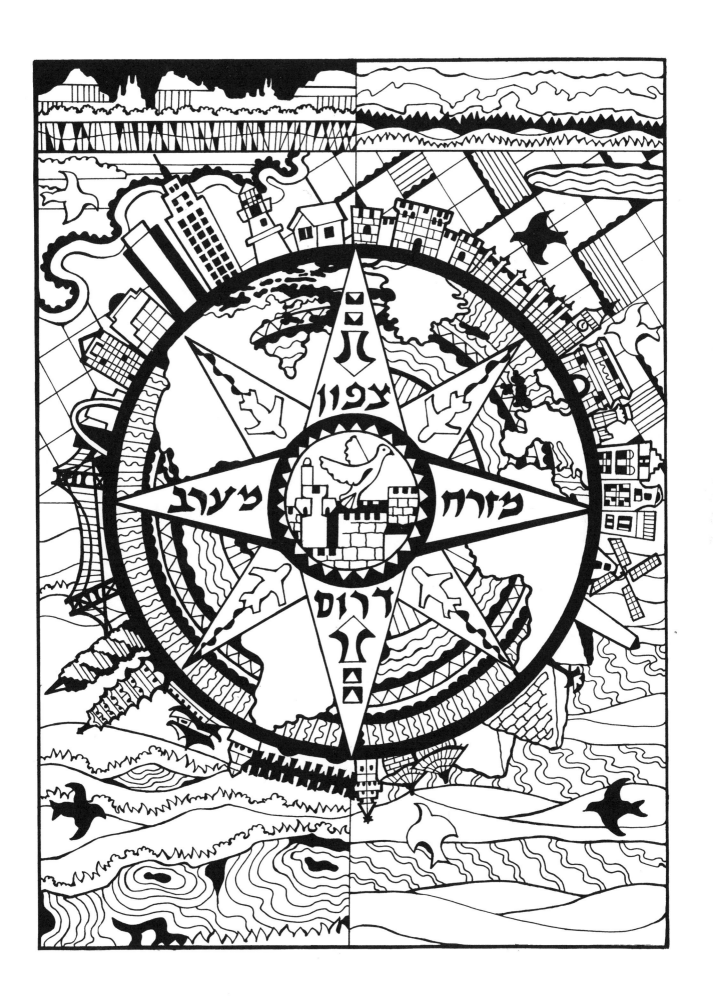

...Yet again there shall be heard...
in the streets of Jerusalem...the voice of joy
and the voice of gladness, the voice
of the bridegroom and the voice of the bride....

—JEREMIAH 33:10-11

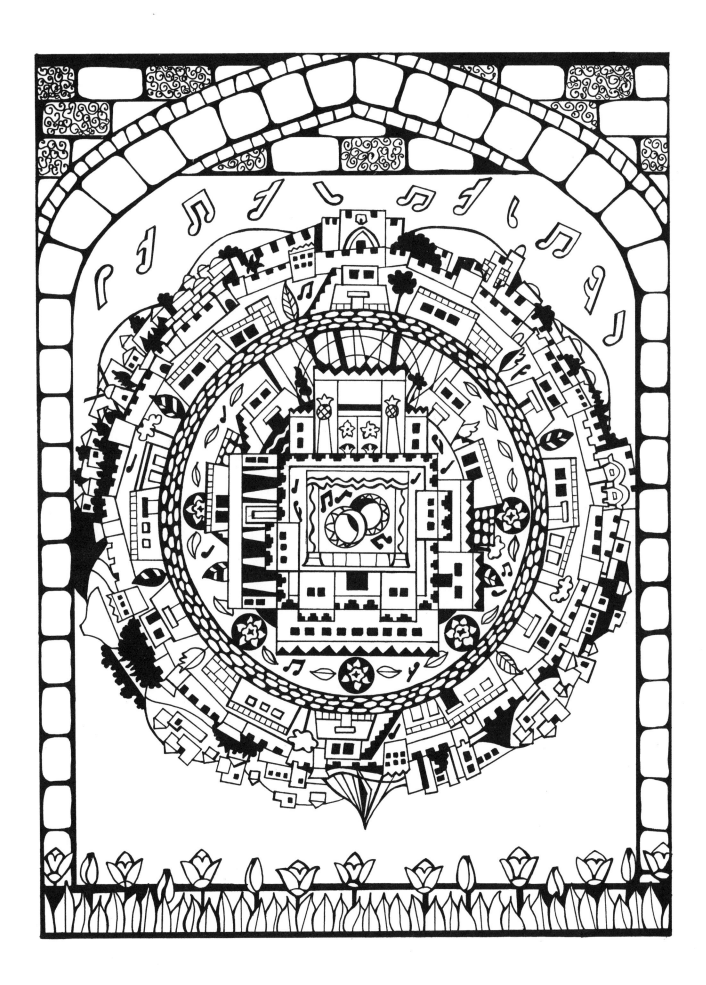

And God prepared a great fish
to swallow up Jonah....

—Jonah 2:1

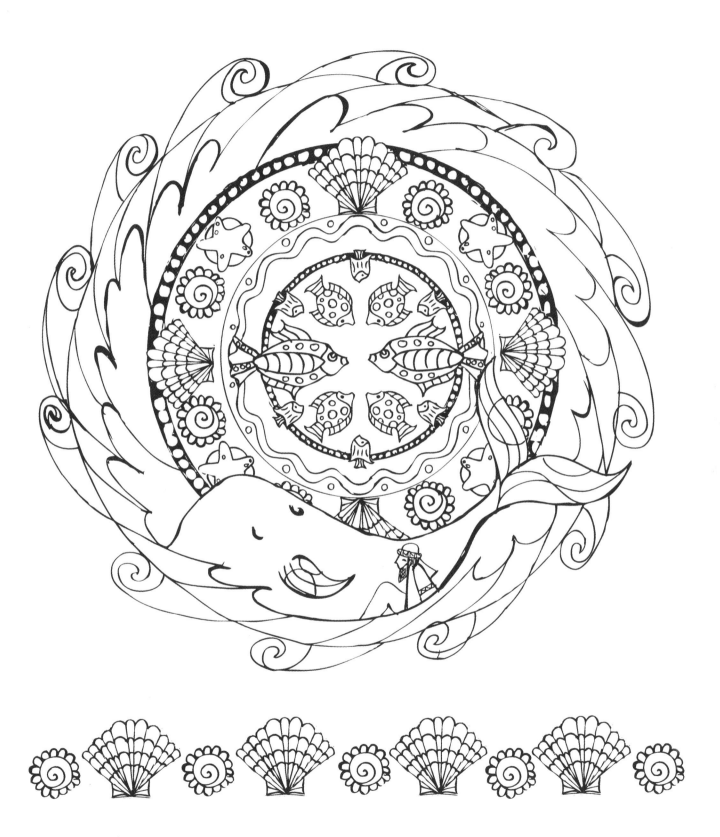

Behold, how good and how pleasant it is for brothers to dwell together in unity!

—Psalms 133:1

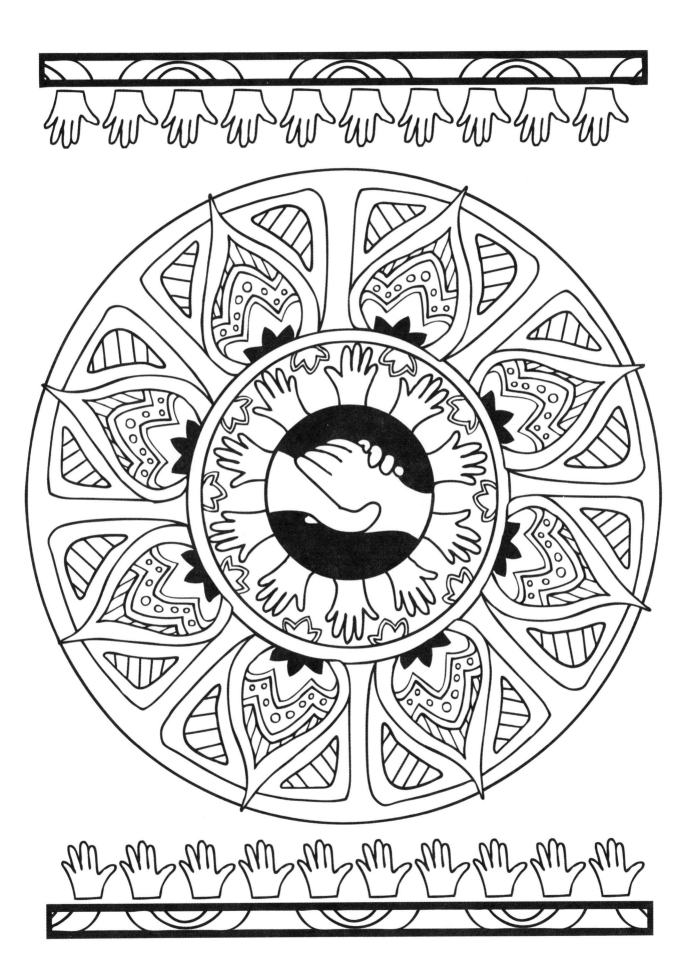

The Torah is a tree of life to them that lay hold to her, and happy are those that hold her fast.

—Proverbs 3:18

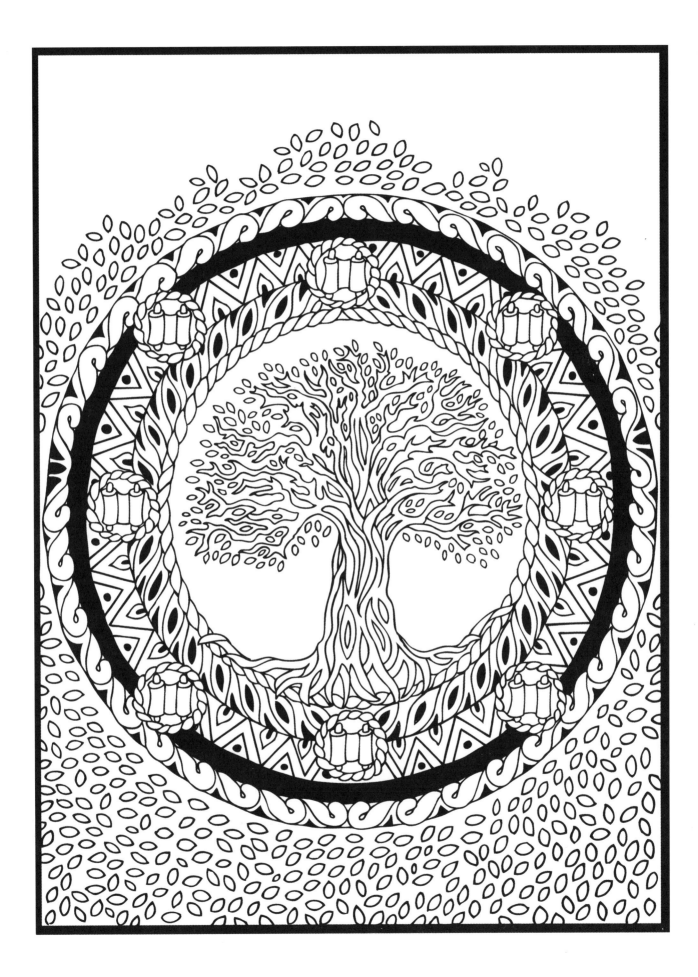

For the commandment is a lamp,
and the teaching is light....

—Proverbs 6:23

I am a rose of Sharon, a lily of the valleys.
As a lily among thorns,
so is my love among the daughters.

—SONG OF SONGS 2:1-2

And Ruth said…"Wherever you go, I will go; where you lodge, I will lodge; your people shall be my people, and your God my God."

—RUTH 1:3

To everything there is a season
and a time for every purpose under heaven.

—ECCLESIASTES 3:1

...[T]he month was turned...
from sorrow to gladness, and from
mourning into a holiday....

—ESTHER 9:22

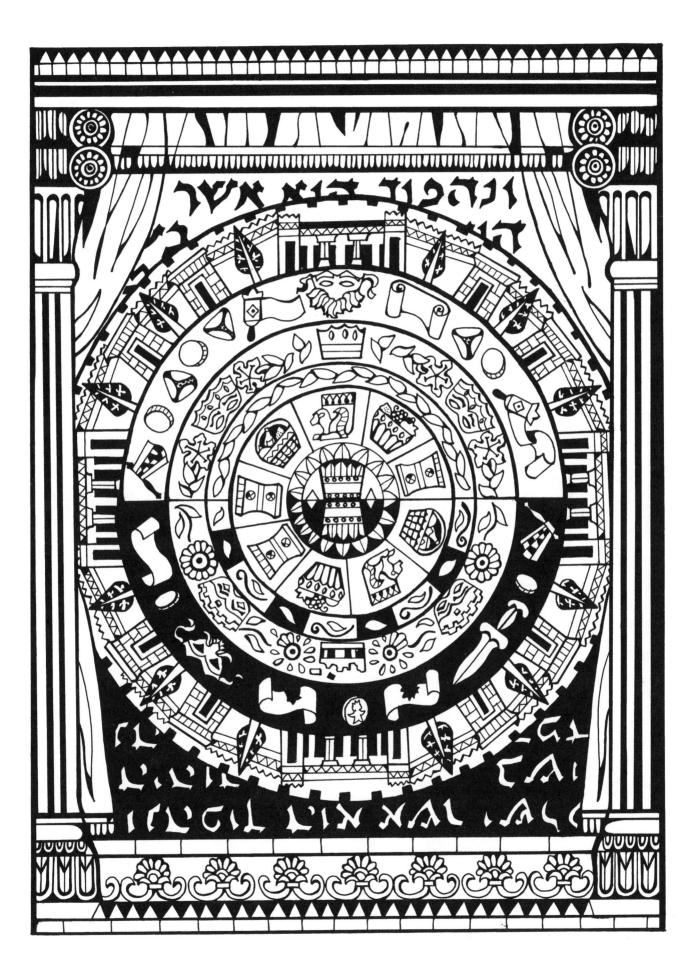

My God has sent His angel,
and has shut the lions' mouths,
and they have not hurt me....

—DANIEL 6:23

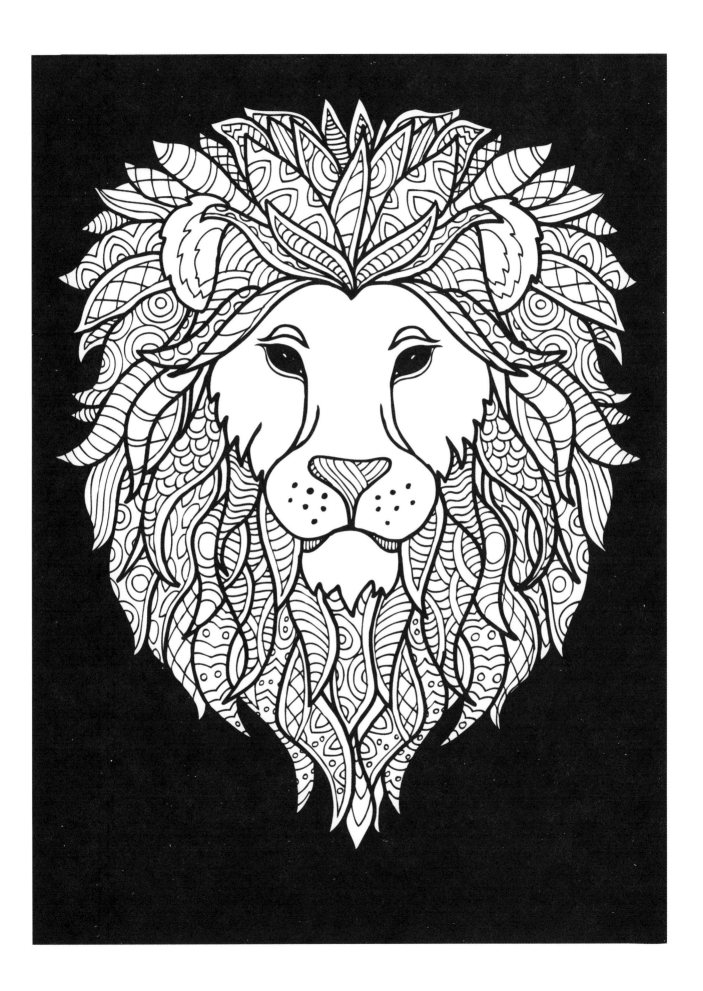